Photography Business

A Beginner's Guide to Making Money as an Adventure Sports Photographer

T. Whitmore

Table of Contents

Introduction

Chapter 1: About Adventure Photography and Lifestyle

Chapter 2: Choosing the Best Sport

Chapter 3: Best Angles and Distance

Chapter 4: Safety

Chapter 5: Gear, Lenses, and Weather Conditions (Oh My!)

Chapter 6: Marketing and Making Money

Conclusion

Copyright © 2016 by T. Whitmore All Right Reserved.

No part of this publication may be reproduced, distributed, or transmitted in any form or by any means, including photocopying, recording, or other electronic or mechanical methods, or by any information storage and retrieval system without the prior written permission of the publisher, except in the case of very brief quotations embodied in critical reviews and certain other noncommercial uses permitted by copyright law.

Introduction

Hello, and thank you for purchasing this book. In these pages you will find the information you need to know about starting your journey as an adventure sports photographer. I hope you find the next few chapters entertaining and informative. Thank you again and enjoy.

Chapter 1: About Adventure Photography and Lifestyle

Adventure sports are the sports that are considered high risk or extreme sports. These are the sports such as sky diving, bungee jumping, skate boarding and much more. These are the sports that you want to follow, but not many people have the guts to participate in. These sports are the ones for thrill seekers and adrenaline junkies to enjoy. There are so many of these sports, and some are not well known. However, even though they are not well known, does not mean that they are not great subjects to be photographed. Quite the opposite really, as the more well-known sports already have a lot of people photographing them. The lesser known sports would give you a chance to shine because you would have a great picture of something that people have not already seen a million times.

This chapter will mention some of the extreme sports that are out there, some of them popular, some of them more obscure, and give a little bit of information on them. Then later on in the chapter, we will go over what the lifestyle of an adventure photographer is like, and how it has ups and downs, but if you

are into fun and thrills, it can be the best thing ever. But first for the sports that you may encounter as an action photographer.

- Blobbing: This is an exciting and rather new sport. It first started as a summer camp activity. However, it soon blossomed into an actual sport. It is done in teams, where the lightest person climbs on the blob at one end, and either stands or lies down. The heavier person on the team then jumps from a good height onto the blob, and catapults the other person into the water. They are judged on height and distance, and you get bonus points if you can do a flip in the air, as that is pretty hard to do.

This is a good sport to photograph, as not only is it fairly new to the scene, it is a pretty interesting sport to capture. There are so many unique shots you could capture that no one else has taken before, such as the unique spread of the jumper's limbs, or the catapultee's form as they are flying through the air. The droplets of water that splash up as the person that was catapulted hits the water. The best part is that you could, if you had a water proof camera, be the catapultee, and capture the image of yourself as you are flying through the air, or as you hit the water. A Go-Pro is best for this.

There are many ways that you can capture these images, and each one of them is thrilling, and a unique experience. If this interests you, get out there and start snapping! (Well not literally, there are still a few more chapters to read, and the rest of this one, but you get the picture.)

- Powerbocking: This is one of the more obscure sports that would be interesting to photograph if you go to the right event. This sport involves people using power stilts to do tricks and flips, and other various dangerous stunts. Power stilts are like pogo sticks and stilts combined, so that you get the spring, but with better balance. It is a fun sport, and can potentially be pretty dangerous if you do not know what you are doing, because there is plenty of risk for injury. However, the injuries are generally not life threatening, unless someone decides to try to jump across sky scraper roof tops, which there is bound to be an attempt sometime if there has not already been a few.

This is a good sport for photographing because it is rather unknown, and it is a very intense sport. There are many action shots that you could take, and there are several possible angles. You just have to know which ones are best, and you will be golden. If you are into

this type of sport, there are several resources for finding angles for a sport where your subject uses jumping motions to propel themselves forward.

- Zorbing: This is a very interesting sport, if you could call it such. It is popular but there are not a lot of competitions that are available for it. However, it makes for good photography. This is a sport that makes you feel like people are hamsters trapped in a skin body. It involves people jumping in giant inflatable balls, and rolling down hills. People have gotten creative with this sport, and have advanced from just racing them, to actually bowling with them, and enacting scenes from movies and video games that involve running from falling boulders.

This is a great sport that you can photograph. You can get the best reactions from people because they are so thrilled, and they are having genuine fun. The best part of this sport is people don't spend months training for it, trying to get every aspect of it perfect, so when you are photographing it, you are photographing pure delight, and entertainment. People are being themselves and having fun. They are not honed, trained machines. They are teenagers, mothers, fathers, and kids. They are families enjoying a thrilling bonding

time. While it is not dangerous, it is an exciting sport that can be considered extreme.

- Scuba Diving: This is a popular sport, and even though it is for recreation and there are no races, it is still a sport and good for adventure photography. Think about it, your subject is hundreds of feet below the ocean's surface with nothing but a tank of air to keep them alive. They are also swimming amongst some of the world's most dangerous and volatile creatures. Of course, to perform this kind of photography, you have to have an underwater camera, and you have to learn how to scuba dive. If this is something that interests you, there are not a huge amount of scuba diving photographers, so it would be a great sport to photograph.

Scuba diving is one of the most beautiful and diverse sports to photograph because every spot in the ocean is unique. Have you ever seen a view of the ocean from underneath? It is breathtaking, and it seems like every time you blink, something is changing. The creatures that you can photograph are amazing as well. There are some thrills such as swimming right past a shark. Chances are you will be okay if you are not bleeding. You do not look like a fish, and sharks don't like the

smell of scuba suits. So snap away dear photographer, as your heart beats loudly in your chest from the fear and excitement of being so dangerously close to something that could swallow you whole. If you are into a thrill that produces beautiful and serene pictures, this is the sport for you.

- Mountain Boarding: This is like skate boarding, only you are going down a narrow dirt pass on the side of a mountain. Extreme, right? One wrong move could result in serious injury, or worse, death. It is not a very well-known sport in non-mountainous regions, but it is pretty popular in the more mountainous areas. This makes it a good sport to photograph, because while it can be popular in some areas, there may not be a lot of photographers in that field. This could be your gateway to success, because then you can make your name in an underdeveloped field, rather than be lost in a sea of submissions in a more popular sport.

Mountain boarding can have some seriously wicked views too. You can get a great shot of your rider coming off a curve, while the background is looking over a city, or a valley. One of the best things about this sport is the view in the background, and the thrill of the subject in the foreground. You just have to know where to look to

get the best possible angles for the best picture you could possibly take.

- Kiting: This is a fascinating and relatively new sport. It involves people attaching a snow or wake board to their feet, and holding on to a massive kite that is designed for this type of sport. Using the wind, they pull themselves along water, snow, and dirt, all while doing flips and tricks. It is like a combination of all of the best board sports, and para sailing without the boat. The best thing about this is that it is a kind of new thing, and does not yet have a million photographers all taking the same picture and trying to get recognized for it.

If you are into the thrill of board sports, but think that you have seen it all before, then this is the sport for you to photograph. With so much versatility in the sport, there are thousands of possible pictures that you could take, and no one has captured them all yet. This is also a thrilling sport to photograph because there are some really close shots you can take if they are doing their kiting on land, such as the boarder jumping over you. This is one of the most amazing angles to capture because it shows that you are right there, and you are a part of the action, and it makes your viewers feel like

they are there and not just looking at a picture. That is the best feeling for an art critic, to feel like they are a part of the picture.

- Barefooting: This is essentially water skiing without the skis. It is a newer sport that pretty much started with "hold my beer and watch this". Okay, not quite, but you have to wonder what was going through the person's head that discovered this could be done. Regardless of what they were thinking, there is no denying that this is an incredible sport. The person who is doing this is literally skiing on water without any thing holding them on top of the water except a rope and inertia. The tricks they perform are amazing as well, because they are not burdened by long and awkward skis like regular water skiers. This makes it a lot easier to capture, because you don't have long wooden or titanium sticks blocking your shot, and there are no awkward shadows to edit out.

This is a great sport to photograph if you like water sports, as it is kind of new, but is well known enough that while you can get your name out there, you can also be sure that there are going to be a lot of people who want to see your pictures. This means that not only will you get your pictures out to sport fanatics, but also to regular civilians who enjoy looking at photos of

sports. You can also get some great angles if you are behind the person or in front of the person on a boat. You also get a clear shot of your subject so no matter what tricks they do, you can properly showcase their abilities.

- Parkour: If you see people randomly running and jumping on things, rather than just going around it, that is parkour. It is literally a sport that involves jumping over as much stuff as possible. The actual definition is moving through obstacles as efficiently and swiftly as you possibly can, but it is literally just an excuse to act like a monkey and show off to your friends. Regardless, it is a pretty adventurous sport, and involves a lot of gymnastic ability. It is great for photographing as well.

You can get the best angles with this sport, because you can stand almost anywhere to get a good shot, and that is what you want to be able to do in photography. This is a key in any good sports photography, and that is to be able to get a good angle, and you don't have to worry about that with this sport, because it is so interactive, that you could literally stand underneath the person and they will just jump over you.

These are some of the lesser known sports. These are the best for you to get into, because they are the sports that not everyone will be photographing, and you can take some pictures with angles that haven't been done a million times over. This is best for someone who wants to be unique and start their own trends. However, the downside is that since they are not as popular, there may not be a lot of viewers for the photos that you take, so you will have to work extra hard on marketing.

There are more popular extreme sports out there that you can get into. You will have to bring something new to the table though, and that is a lot harder in a popular sport, because there are so many people vying for the same spot that you are trying to get. However, there are a lot of viewers of these sports, so marketing will not need to be near as aggressive. This gives you more time to focus on getting the perfect shot, and maybe making your name in the industry a lot easier than it would be if you had to market yourself aggressively. It all depends on what you prefer. If you prefer uniqueness, then a more obscure sport is probably best for you. However, if you want to shine in a sport that is well known, then a more popular one may be what you are looking for. This is your choice, and here are some of the more popular sports that are out there

- Water skiing: This is a sport that involves long wooden or titanium planks that hold a person up on the water so that they can skim across it at high speeds. They are pulled along the water using a rope that is attached to a boat. The most extreme skiers use the wake created by the boat to do tricks, and do a type of surfing, called water boarding. (Not the torture, the sport.) Water boarding is the same concept as water skiing, only you use something that resembles a snow board rather than skis.

 This is a good sport for photography because you can get some pretty cool pictures of people doing some intricate jumps and flips. Be careful however, because the board or skis can create a shadow, or block your subject altogether, so you have to really focus on getting your timing perfect to get the perfect shot.

- Solo Climbing: This is an insane sport, and photographing it can be tricky. However, it brings a great thrill because you could literally see your subject doing the most life threatening thing on the planet. However, it is also terrifying because if they do not have the grip of death, then they easily could fall to their death. These people are the most intense of any athlete, and that is what they are. Athletes to the core, because it takes a lot of practice, time, and effort to be able to

free climb. This sport involves the athlete scaling the side of a mountain without any safety gear. They literally rely on their own grip the entire way up, and sometimes the grip holds are literally only big enough for fingertips. While this is an adrenaline infused sport, it is not for the faint of heart, because you have the chance of seeing something very gruesome that you probably could go your entire life without seeing.

However it is a great subject to photograph, because while it is insanely popular, there are not a lot of people who are willing to photograph it for fear of seeing their subject fall to their death. If you have a strong disposition, then you could be perfect for photographing this sport.

- ☐ Bungee Jumping: This is one of the greater known extreme sports, and it is a thrill for all that experience it. There are plenty of photos of bungee jumpers though, and as there are not many angles that you can photograph from, it is best to avoid this sport when starting out.

There are some of the more popular sports, plus one that you would do well to avoid, unless you are going to try something that has never been done, which would be photographing

someone on a double jump.

Now on to the lifestyle of a sports photographer. These people are some of the most thrilling people there are because they put themselves and their safety on the front lines. They are literally in the path of some of their subjects which could get them seriously injured. So to be a sports photographer, you have to be a thrill seeker yourself. If you are a thrill seeker and an adrenaline junkie, this could be the job for you.

There are several things that you need to remember when you are a sports photographer though. The first is that no matter how much of a thrill seeker you are, your safety should never be on the sidelines. No shot is worth your life. A lot of times, sports photographers get so addicted to how thrilling it is to have near misses, that they push the envelope farther and farther, until eventually they slip and get injured, or worse, killed. If you are able to keep your safety in mind, you should be able to do just fine.

Secondly, you should always remember that the gear makes the person. Later on in the chapter, we will discuss different things that you could need as an action photographer. You want to be able to get all of the action, no matter the weather conditions, or the angles that you have to be able to get. If you do not have the right gear, you could miss out on what could

be potentially the winning shot, and that is not what you want to do.

This is a dangerous job, so do not try to get into it if you are not prepared to put yourself in some dangerously tricky situations. Because no matter how many safety precautions you take, some of these sports you will be capturing can be unpredictable, and to get the perfect shot you have to put yourself on the front line. If you are willing to do this, and enjoy it, this could become a life career.

Lastly, have fun. There are so many opportunities for you to get out there and enjoy yourself. You are not going to get the perfect shot by standing on the sidelines trying to coordinate everyone. You get the perfect shot by getting out there and getting involved. This is not a profession where you can control everything. If you are looking for that, you might want to try portrait photography. However, since you are reading this book, there is a high chance that you already know that this is an unpredictable profession.

In photography, most people who are not photographers feel like it is an easy profession. This is not true, you have to capture the essence of people in a still frame. This is easier said than done, because humans are naturally moving. This is even more of the case with action photography. You are

literally trying to capture the moving world in a still photograph. If not done properly, this could turn into a blurry indistinguishable mess. You are the difference between a masterpiece, and just a simple picture. You are the artist, and that in itself is a lot of pressure. Not to mention the high pressure life of adventure sports and action photography.

That being said, this life isn't all bad. There are a lot of perks, and we aren't just talking discounted tickets to the biggest sports events in the world. We are talking personal perks such as the thrill of being so close to, or part of the action. The joy you get seeing people act out their passions. The recognition you get from your photos is unrivaled by anything other than the thrill of the near miss you had when you took that photo.

This is a life of thinking ahead. You have to plan in advance, which means that you have to know the sport that you are photographing. That way you can be in the right place at the right time. You cannot rely on luck in this profession. While it is a contributing factor, you also have to be able to put in your own effort to keep things safe, and to get the best type of shot. You have to plan ahead with angles, gear, and with your own stances. You want to follow the action and simultaneously be ahead of the action. Since there are not two of you, you have to plan accordingly. This is a very intellectual profession due to all of the planning. It is like you are engineering a photograph

except you are not simply pressing a button. You are conducting a symphony within your camera of light, shadows, shutter speeds and depth. There is so much you have to think about at one time, while also focusing on the action at hand to time everything just right.

Life as a sports photographer is also busy. You often have to go to several events in your chosen sport(s) to get the shot you need. You could take a hundred shots at any one event, and while they might all be of good quality, none of them are the money shot. This is a real possibility. You have to always plan to go to at least ninety percent of the events that are scheduled for a season in your sport. This means a lot of travel, and a lot of time packing and unpacking gear. Most of the time you will only get one or two great pictures, but those pictures will be what earns your bread for the season of that sport.

You are literally creating what some people could never even imagine. You are creating a separate reality for your viewers. In this reality, everything is still, calm and perfect. Yet you can also feel the chaos and the thrill. You can definitely change someone's perception of a sport with a photograph. You can show someone the gruesome truth, and the beautiful honesty of that sport. You can create a whole different air about you that is totally separate from your real life. You can live in the most serene place in the world, but lead people to believe that

you have a loud, thrill filled life, when in reality that is only a small glimpse of how you spend your time.

There are a lot of times where you work long hours without a break though. You don't want to move for fear of missing "the shot". This means that you often miss meals, and that you are tired when you finish. However, if you get that perfect shot, then it makes it all worth it. You get dirty, you get sweaty, you get hot, and you get cold. You have to deal with the elements and the noise. Then you have to tote your heavy camera bag everywhere. However, when that paycheck rolls in, no matter how much you were cursing the day before, it makes it all worth it.

Sports adventure photographers are the ones that take the photos in the sports magazines. When you see a photo of a NASCAR race, it was a sports photographer that took that picture. There are so many pictures out there of sports, and they were all taken by people of your profession. Each of those photos has a story, and each of those photographers has a life.

They are all joined together through the lifestyle of sports photography. The hard days, and the cold nights. The long hours they put in, and the hundreds of shots they took until they got "the one". The lifestyle where you put your safety on the line every day alongside the athletes, just to bring

entertainment to the world of people who could not get to the event themselves. For these people, it is not about the money. It is about bringing the joy they feel when they enjoy these sports into the hearts of others. It is about translating the emotions they feel into one still shot. It is only having one shot to tell an entire story. That is the lifestyle of a sports photographer. It is more than the people that they meet, and the places that they get to see. It is more than the fancy camera, and high end gear. It is the work and the passion that they put into it to get to where they are now.

Imagine the best story that you have ever read. For example, let's use the Harry Potter series. It is a series that most people know, and most of today's generation grew up with. It is a favorite of many, because it puts joy into people's hearts, and gives them a tale of magic and wonder. They feel they get to learn and grow throughout the books and with the characters. There are millions of words that are read to translate this story, and it spans across seven books and eight movies.

Photographers are telling a story as well, the only difference is that they are doing so with one photo. They do not get a bunch of rough drafts. They may take a thousand photos, but they can't edit them to get the money shot. The best photos are raw. So in reality they only get one shot to tell the story in that moment. That is what you are going into, and it is a truly

wonderful and heartbreaking thing. Wonderful because you can tell a story with so little information, heartbreaking because of all of the attempts that it takes. It can be discouraging at times, but never give up, because it is all worth it once you have that one picture that tells your story, and you are able to share it with the world.

So that is the lifestyle of the action photographer. If you think that you have what it takes, continue reading to find out more about lenses that you should be using, safety precautions that you should take, gear you should use, and angles that will make your shot the one everyone wants to buy.

Chapter 2: Choosing the Best Sport

It is no secret that if you do not choose the right subject then you are going to not be the best at the photographs you take. You have to know the sport inside and out to really succeed. This means you should choose something that you are interested in. Something that you are willing to learn more about, and take some lessons in, so that you can really think like the athlete in order to get the perfect picture. You also have to choose a sport that fits within your range and budget. If you are in grassland, unless you have the finances to travel long distances, you might want to stay away from mountain sports.

When you are picking out your sport there are a few things that you should remember, as you want to pick a good one to capture that also fits your parameters. This is pertinent, as you could be picking your favorite sport, but it is not as unique as you would like, or it costs too much to follow. So following these tips will help you choose the best sport for you.

- Find What Clicks: First off, find the sport you want to follow the most. Whether it is a water sport, a dirt sport, an air sport, or a snow sport etc. You have to find one that you would be willing to train in, and one that you

would be willing to put in a lot of hours researching. Once you find this sport, it is time to look more into what it takes, to make sure that it is the right choice for you. It is best to find a few sports so you can narrow it down.

- Research: You have to look into every aspect of this sport. Not the training part yet, though that is important. You need to research the gear that you will need and the safety precautions that you will need to take. The things that you need to make a masterpiece. Also you have to research schedules for the events, and how far away they are to see if the sport is a viable option for you.

- Budget: Make a budget. Tally up how much disposable income that you have to get you started, because to start this business you have to have some money to buy equipment and to get into events. A few might let you in free, but that is coming up. You also have to plan for travel expenses. Prices of fares, gas, rental cars, hotels, and the list goes on and on. If you are just starting out on a tight budget, you might want to start closer to home.

- Research some more: Look into the events that you

would like to go to, and call to see if the hosts of the event would like to make a deal. Be careful with these though, because even though you could get free tickets, you may have to give up the rights to your money shot for free. Not all event hosts are like that though. Some are kind, and they keep your name attached to the photo, they just want permission to put it up on their website.

- Finalize the Sport: Once you have decided on which sport works best for you, it is time to start learning more about it. Maybe take a few lessons, and read as much as you can about it. Really try to get into an athlete's head, and try to think like one. This is the best way to really become a great sports photographer.

Of course there are some sports that are better than others, and some are hot on the market right now, while others are not. You may want to learn more about a few sports so that you can have some work even on the off season of your chosen sports. Plus variety is always good to have, as it will help get you some recognition a lot faster.

Some of the best sports to focus on right now are things that are just coming into popularity, such as parkour, or barefooting. These things are quickly taking up precedence in

the sport world, and you should get in there while the press is hot on them. You can get recognized in a developing area, and not have to fight for a spot in the spotlight.

Why You Should Choose a Newer Sport
The sports that have been around for years already have seasoned pros taking pictures at those events, and the angles have all been seen before. People want to see something new, and they want to see something that is relevant to their lives. The newer sports that are coming into the light are what are catching people's attention right now. You want to be where the people are, not where they used to be, and not where they may be in the future. You want to be in the here and now. That is why sports that were mentioned in the first list in chapter one are the best sports to start out with, because you can grow with them.

There are so many perks to choosing a newer sport. For example, the barrier of entry to a new sport is a lot easier. That makes it easier to get your name known. A lot of the events are cheaper, some even being free aside from travel which makes it great on the budget of a beginner. Choosing a newer sport also gives you the ability to showcase your unique talent, because people are really going to be looking at all aspects of the photo rather than just looking for the wow factor. In sports that have been around for a long time and that have been

photographed a lot, you are not relying on skill anymore, you are relying on luck to get that shot that no one has seen before, but with a newer sport, it is skill that you are relying on. And the critics are going to be looking for that. They will be interested to see new techniques and new content, rather than burnt out on yet another photo of a skydiver jumping out of a plane. You have a better chance of making it in this career if you do choose to follow a newer sport.

That isn't to say that you have to choose one from there, there are a lot of other up and coming sports out there. And you can choose an older sport. If that is what you are attracted to, then follow your heart. You are not going to get a good photograph if your heart isn't in the game. Find more ideas on sports to photograph at https://iso.500px.com/a-day-in-the-life-of-extreme-actionsports-photographer-tristan-shu/

Chapter 3: Best Angles and Distance

In photography, the best pictures are the ones that have the perfect angle, and that are the perfect distance from the subject. As a photographer, you have to be the one to make the decision on where you want to be, and what distance you want to be at, or appear to be at. This will determine your stance, and how close your subject looks to be to you. You also have to decide what you want the picture to feel like. This determines the angles you use. Everything is tied in together. That means that you cannot go on to the next step without making a decision on the current one you are on.

When you want to get the best angle, there are a few tips that you should remember. These tips will help you choose the angles that you want, and help you get the picture that will make your name in the books.

- Feel: You have to decide how you want the picture to feel. This will decide the side you want to approach the subject from. If you want it to feel heroic, then you will shoot from underneath, if you want it too feel humble, then you shoot from above, and so on and so forth. The

spot you choose to shoot from will determine the feel of the picture, and vice versa.

- Remove fear: Too many photographers are afraid to shoot from certain angles, because they have been told that they are photography no-nos. The best example is shooting from underneath. Photographers are told that this elongates the subject too much, and that it should be avoided. However, in action photography, it is a great angle to shoot from, because it gives the picture a really deep and emotional feeling. Stop fearing angles, and get out there and try something new.

- Let it happen: Don't grip so tightly to an idea that you lose the perfect picture, because you didn't want to use that angle. You have to be willing to make on the fly changes to your approach to get the picture that you want. Sometimes you may think that you want one angle, when in reality, you need one that is almost opposite. This is much different than portrait photography, where you shoot from the angle you want to shoot from, and make the subjects move where you want them. In action photography, you have to shoot where the action is. The picture does not come to you, you have to go to it.

- Have fun: You have to have some fun with your angles. Take a picture from a few angles that you feel won't deliver a perfect picture. You may be surprised at how good the photo actually turns out. If you loosen up and have fun with your angles, then you will be able to get the shot that you need.

Angles are an important part of photography, so while you should have a general idea of the angle that you want, you should also be willing to change your plan up. Especially in action photography. Most sports are so unpredictable that you have to make a lot of decisions on the fly. That is okay. All you need is knowledge of the angles that are available, and how to achieve them with the camera that you own.

Distance is a whole new ball game though. It is very important that you know the distance that you want to be from the subject. Not only from a photography aspect, but also from a safety aspect. While a close up, wide angle shot may be desirable, it may put you in the danger zone. That is the area that you want to stay away from. The danger zone is where you put yourself at risk, along with the possibility of putting your subject at risk as well, as they could hurt themselves trying to avoid you.

There are a few things that you have to remember when you

are trying to decide the distance that you want to be from the subject. These tips are not law, but they are good guidelines to follow if you are not sure where to start on finding distance.

- Know your location: This is important. You have to know where you are going to stand, so that you can ensure that spot will be open. Spectators do not like to move, even for a photographer, and you could find yourself having a hard time getting to your desired spot, potentially missing out on some good photos if you are not already there. It is always best to show up early enough to find the best place for the action. If you do not scope out the area, you could miss out on the best spot.

- Stay out of the danger zone: Unless you are a seasoned pro, the danger zone is not for you. Try to stay as far away from it as you can while still getting a good shot. This is important, because some danger zones could cost you your life. Especially at something like a NASCAR or Indy 500 event. Other danger zones can get you seriously injured. So it is best to stay away from them if at all possible.

- Shadows: Always make note of where your light source is going to be at any given time. If you don't, you may

have a good shot of the action, but it could be ruined by a pesky shadow that is out of place, obscuring a very important detail in the photo. Shadows are good on some photos, but you want to try to keep them in their desired positions. So always take shadows into account when you are in a location.

- Width: How wide do you want the shot? You have to decide how wide you want it to determine how close you have to be to the subject. The wider you want the shot, the closer you have to be at more of an angle. When making this choice, always keep the danger zone in mind.

Those are just a few things to remember when you are choosing your distance from a subject. Again, you can omit some of these if you have better tips, these are just a guideline. But above all, know your subject, and don't be afraid to play with distances. From spectator distance, to close ups, the possibilities are endless, and they all can deliver some really good shots.

Chapter 4: Safety

This chapter may seem a little repetitive not only on itself, but from things stated above, but that is because safety is of utmost importance. As mentioned above, no shot is worth your life. This profession is not a desk job, so often there is no insurance that comes with it. You have to take your own wellbeing into account. Too many times these days you see sports action photographer putting themselves in harm's way just to get the perfect shot. This is not okay because a lot of times when you are putting yourself in harm's way, you are also putting other people at risk. Not only the athletes or your subjects, but anyone who may be brave enough to try to save you as well. You always have to keep safety in mind, and do not pass those mental lines.

Safety has become a hot topic as of late, and a lot of seasoned pros will say, "the danger zone doesn't exist. Look at me, I'm still fine." In reality, these people are just lucky. They have been graced to have not been injured, or worse, killed while they are disregarding safety precautions to get a good shot. I recently watched a video where a photographer was at a NASCAR race. He was on the edge of the tarmac at a corner

where wrecks were common. He had a foot on the pavement and sure enough, two cars came screeching around the corner. One of the cars lost control and smacked into the other missing the guy by mere inches. What does he do? He finishes taking the pictures, unscathed, and walks away. I know after a few years you get used to the thrills, but such a blatant disregard for general safety is a big concern.

You have to be concerned with safety at all times, not just when it is convenient for you. You have people that care about you, and how would they feel if you got hurt on the job and it could have been prevented if basic safety measures were taken? Not trying to cause a guilt trip, just pointing out the severity of not being safe. This job is dangerous enough without added problems from disregarding personal safety.

Bottom line is that the danger zone does exist, and you would do well to remember that. If you are in an area where you could very easily get killed, and it is not going to be a one in a million hit, you should stand elsewhere. If you are in the middle of the action, and could get seriously injured, you should stand elsewhere. Unless you have already warned the athletes or other subjects of your photos that you are going to be in the middle of the action, stay out of the way. They could seriously injure themselves trying not to hit you, when you just wander into their way trying to get a good picture. Some places

will even ban you from further events if you do not get an okay to stand in the danger zone. That is because safety is so important. It is the reason it has a whole chapter devoted to it.

There are a few tips that you should remember when you are photographing the events that you are at. These tips should be considered the holy grail of tips until you are experienced enough to figure out your own. If you have a friend in the field and they have some better suggestions, by all means go ahead and follow those too, but for now here are some general tips.

- Gear: You should always have the proper gear with you. Not only protective gear, but also camera gear. In another chapter we will talk about some things that you may need, and why gear is so important. But it is also important when it comes to safety, because you don't want to have to risk your neck trying to keep your camera safe.

- Clothing: You have to have the right clothes for the weather conditions. You do not want to be wearing shorts in the Swiss Alps and a fur coat in the desert. Clothing will keep you from getting ill due to weather conditions, so make sure that you pack accordingly.

- Mind the Danger Zone: This is a real thing, and you

should do well to keep in mind these zones. If you are unsure of where they might be, ask around. Safety is the number one thing, and you do not want to be standing where you could get yourself or someone else hurt.

- Limitations: Keep in mind your own physical limitations. You do not want to be doing something that is beyond your physical capabilities, otherwise you could get seriously injured. If you are not good at free climbing, and your subject does not want a photographer using ropes, maybe find a different subject, because your safety is the number one priority.

- Condition of Safety Gear: Lastly, make sure that your safety gear is up to code. If you are scuba diving, you do not want your hose to be old and cracked. You have to make sure that all of your gear is ready to go each season, and that you are going to be safe when you go to take pictures. Inspect each piece of gear for wear and tear, and make sure that you have everything that you need.

The safety of yourself and others around you is the most important thing of all. You have to make sure that you are where you need to be and that you are taking the precautions that you need to take. Safety is above all else, the most

important thing.

Another thing to remember is to follow the athlete's lead. If they are leaning one way, then you better lean that way too. Especially if you have to be in the middle of the action. They can see a lot more than you will be able to looking through that viewfinder. This is a mistake a lot of rookie photographers make. Sometimes you have to look away from the viewfinder. Pay attention to your surroundings and make sure that you are safe. You cannot see everything if you are looking into a tiny box at a specific target.

Above all, use your common sense. If it seems dangerous, or like it could be bad if it is not done right, and you are not sure how to do it. Don't do it. This shouldn't have to be said, but the amount of photographer injuries states that it should be said. It is not meant to be an insult to your intelligence, merely a reminder not to get so caught up in the moment that you lose your head. Quite possibly literally.

Chapter 5: Gear, Lenses and Weather Conditions (Oh My!)

This chapter is kind of a catch all of information. These are good together, as a lot of them tie in together, so here they are. Together. Have we said together enough? Yeah? Okay.

Anyways. It is very important to have the right equipment for when you are trying to get a great shot, and you need to know what weather conditions are right for shooting. Here you will learn the basics of what you need, and what determines what you need to be a success. Also we'll discuss how to handle weather conditions and know when to take cover, because a lot of athletes will not stop for anything unless they really have to. Unless you are that extreme, it is best to keep yourself and your equipment safe so that you can continue doing what you love at a later date.

Lenses

Let us start with the best lenses for this profession. You want lenses that will give you clarity both close up and farther away. Image stabilization in the lens is a bonus, but it is not required for a good shot if you have a steady hand. There are good lenses for beginners, and there are lenses that are good for

pros. Since this is a book geared towards beginners we will stick with those. The first thing that you have to think of is what type of camera you want. Do you want a standard DSLR, or do you want a mirrorless interchangeable-lens compact camera?

A DSLR is what you would generally think of when you think of a camera. It is the big professional camera that you can attach a telescope lens to, similar to the ones you see on the sidelines at a football game. It is the type of camera that most standard photographers use. The only downside is that it can be heavy and bulky, and is not great for places where you need something light and compact.

A MILC is a compact camera that you can change the lenses out like on a DSLR, but it is small and versatile. You have the ability to maneuver it around a lot better without the bulk and without the weight. Shutter lag is almost nonexistent with the newer ones, and they are quickly over taking the DSLR market. However the aperture is generally a lot smaller so you have to raise the ISO considerably.

Both are good options for the sports photography, however, the choice that you make will drastically influence the lenses you buy because you have to buy different types for different cameras. Also, lenses change from camera brand to camera brand, so you have to find what works best for your particular

camera.

If you are just starting out, and let's assume that you are, you will probably want to buy a kit lens. These lenses now come with built in image stabilization and they are great if you are trying to learn the basics. If you are making this a profession, then you have probably had instruction on the different types of lenses and what they do, so it is just a matter of choosing the right one for the job.

There are a few tips to help you figure out what lenses you will need to do the job well and get the best shot. These tips do not lead to a certain lens itself but are things to think about when you are trying to choose a lens. If you follow these you should be able to choose the right lenses for what you need.

- ☐ Distance: You have to keep in mind the distance you are going to be from the subject. This will tell you what type of zoom, and what type of resolution you will need. If you are trying to capture close ups, then you will need a lens that is good for wider angles. It all just depends on how far you need to be from your subject.

- ☐ Angle: The angle is important when choosing a lens as well. If you find yourself constantly using a certain angle, go for a lens that is compatible with that angle, and makes shooting it a lot easier. Look for size, zoom,

and resolution to get the best shot possible.

- Background: Believe it or not, the type of background style does affect the lens that you need. Some are better for clear background, some are better for a soft background, and some are better for a super blurry background. Take into account the type of pictures that you want to produce and what you want the background to look like. Use this knowledge to choose the lenses you need.

- Subject clarity: How clear do you want your subject? And before you say you want them to be really clear, what if you do not? Sometimes the background is the most important shot you can get. It all depends on what is going on that day, and what you want to get. Make sure that you have a lens that will focus on the background more than the foreground, even if you only have one.

- Specialties: Do you have special camera tricks? If you do you might want to make sure that you have a lens that can do what you need. A lot of people try to adapt their lenses that they have currently to fit their needs to save money, and while that may work sometimes, a lot of the time, you need the right lens to do the job.

Otherwise you are not really that much different than a hobby photographer.

Find a good group of lenses. Most people have three or four, but real photography enthusiasts have more than that. The most important thing is that you find the ones that suit your needs and you use them well. However, you should also use them in the way that they are meant to be used. Adapting your lens to try to get a different shot could ruin the lens entirely. Stick with its original purpose, and when you have the finances, buy the one you truly need. You will save money in the long run.

Once you have found your lenses, you can begin to set up a plan for when you are going to use them, and what shots you are planning on taking with them. Don't set your plans in stone though, because you may have to change them in a moment's notice.

Gear
Now it is time to talk gear. If you are looking at your bank account saying "what am I thinking?" relax. You often can find this stuff online for relatively cheap. You do not need the most expensive brand of equipment, just make sure to check the reviews to ensure that you are getting quality products for your money. Stay away from gear that doesn't have reviews,

because that in itself is a bad review. You can find the best deals on places like www.ebay.com or www.craigslist.com if you look hard enough.

Now that you have gotten over the mental crisis and momentary self-doubt that you may have just had, let us move on. There are some things that are important to have, and some tips to know what else to look for. However, you do not have to get everything on this list at one time. Just be prepared to do some extra things to ensure camera and physical safety when you are out shooting without them.
Here are some of the gear pieces that you will probably need.

- You will probably need a sturdy camera bag if you do not already have one. A lot of people use a backpack, but those are not protected enough. There are special bags with reinforcements in them to help protect your camera and lenses from damage, and keep the bag from ripping under the undistributed weight. You will probably want the backpack style one, as they are the easiest to transport in tight places. The best ones to get have extra padding on the straps, and waist clips so that you can distribute the weight better. Not only that but waist clips are also awesome because they make it harder for people to steal your bag.

- Tripods are a must. You should have a few different ones for different shots. They make sure that your picture is steady so an adrenaline rush does not make your hand shake. Of course, there are places where a tripod doesn't work, so you have to know how to keep the camera steady without one as well, but in places where you can use them it is always great to have them. There are several different types to consider. It is best to have a small one for when you are trying to get a low angle. You should also have a medium sized one for a general angle and a tall one for a high up angle. These tripods will help you get a clear shot every time you need one.

- Lcd loops and electronic viewfinders are a big help so that you can see the shot without having to beat the glare of the sun. There are several types out there, and you can buy many different types for cheap. These help you ensure that you are getting a good shot, and there is no guess work involved. These are not a necessity, but they do help out a lot.

- Something that can save your camera and preserve it for years to come is a real and reliable rain guard. A lot of people use trash bags, but these are not meant for cameras and often do not cover everything. Sometimes

they even cover too much, making it difficult to take the shot without exposing your camera to the elements. A real rain guard will be custom made to fit your brand of camera, and they will protect your equipment from the elements while still making them easy to use. They are definitely worth the cash up front, and should be one of the first things you buy, because you never know when the rain is going to strike.

- This is probably a given, but you need a good camera. There is no specific brand, just make sure that it has good reviews and is reliable. It should have a frame speed of six frames per second or more, and have a continuous mode. This makes it a lot easier to shoot high action clearly. It should be easy to use so you can make adjustments at a fast pace. Having a good camera is the most important part of this profession. The most affordable of the recommended brands tends to be Pentax. This is a brand that is affordable and reliable, coming in at half the price of a Nikon or Cannon camera of similar specs.

- Remote cameras are again, not a necessity, but they are a huge help for when you want to get close to the action without being in harm's way. They are not cheap though, so they would take some saving for if you do

not have a lot of disposable income. With a remote camera, you can get in places where it would be too dangerous for you to stand yourself. Such as right on the edge of the track. Just set it up, and use your remote to take the picture at the right time from a safe distance away.

Those are some of the gear items that you should have in your bag. Some are a major necessity, some are just really helpful to have. You can decide for yourself what you need, although don't forgo the rain guard. When you are choosing gear make sure you have what you need for your particular sport. Oh, yeah, don't forget. You need a rain guard. Okay, all joking aside, gear is important. Outsiders do not realize just how much you really need to be a photographer. They think you just pick a camera, point and shoot with any old lens, and BAM, instant fame. This is not the case. It is all in the lenses and gear that you have.

Weather

You have to know how to handle the weather to be a good photographer, and you also have to know the general weather of the region in which your sports are generally located. If you know the weather patterns, it makes it easier to prepare for it with clothing, gear, and a shelter plan if necessary. You should also have a first aid kit in your bag at all times. Not part of the

weather, just a necessity.

If you are in an area where tornadoes are common, it is best to go with a plan of action to ensure that you can be safe, even in the event of a tornado, because some places schedule events even if there is a tornado warning in the area. Some places don't, but a lot in tornado alley do. Find a shelter that is close enough to get to in case of a little warning. Have a packing plan so that you can get your gear torn down and packed in a quick swipe. And lastly, run if required.

If you are in a place where it is very snowy, make sure that you have a warm coat to prevent getting sick, and make sure you have an insulated weather guard to keep your camera from freezing if it gets that cold. If you are in an area where it is slippery, make sure that you have ice cleats so you do not fall and injure yourself. Snow shoes help as well if you are in a powdered snow area.

If you are in an area where flooding is common, bring an inflatable raft. Seriously. A lot of them can be folded into something that can fit in your bag easily, and they do not inflate until you open them. Also, have a plan to get rescued if you do get caught in a flash flood. If it only rains then make sure to use your rain guards that you have probably purchased by now.

If you are in an area where fires are common, then you should probably have a plan of action to outrun the fire, or stay out of that region, because fires don't mess around. However, if you do find yourself in a situation where a grass fire starts and gets out of control at your event, it is best to have an escape plan. You probably won't keep a fire extinguisher on you, but a few clean rags to breathe through are a good idea.

Weather can be volatile, and no matter the amount of planning that you do, you can still find yourself in a situation that you were not prepared for. The best thing to do is keep calm, and clear your head. Use common sense, and do not put yourself in a dangerous situation, even if it means harming your equipment because you cannot pack it up fast enough and have to leave some behind. Items can be replaced, even if they are a little expensive. That is what insurance is for. You have to think of your safety above all else. You cannot put your equipment above your physical being, and if it is you or the camera, choose yourself because the camera can be replaced, you can't.

Here are some tips on handling the weather if you are not quite sure what you should do in the case of a storm of sorts.

- Ride it out: If the storm is not too violent, try riding it

out. You do not want to miss out on a good shot just because it is raining or snowing a bit. That is what rain coats, umbrellas, and rain guards are created for. If it is just a mild storm, continue watching the action with your protected camera, and focus on getting a good shot. Just keep an eye on the storm and look for worsening conditions.

- Watch the crowd: A lot of times, if a crowd is gathered, the event hosts will not stop the athletes, no matter the weather, unless it becomes a physical threat to them. They wait until the crowd starts to disperse, and then they will decide to stop the event, or delay it till the storm passes. If the crowd starts to thin out, you should probably follow, because if it is bad enough for spectators to disperse, then that means it is getting pretty bad.

- Keep Safety in Mind: If it is getting too difficult for you to remain safe while trying to take a picture, then you should probably head to a safe place. You may not have gotten the shot you wanted, but you can always try again at a later time. Safety is the number one concern in inclimate weather. You have to make sure that you are doing what is best for you, so that you can continue doing what you love for years to come.

- Leave When Instructed: If you are instructed to leave and seek shelter by someone, then it is best to heed the warning. Don't try to get in one final shot, leave. It may be a beautiful picture, but safety is the most important thing that you need to think about. Not a photo, not your gear, your safety.

Those are some safety tips but remember, just because weather is volatile, does not mean that it is not beautiful. Do not be scared of a little mild weather. You just have to know when to take shelter. If you can get some weather elements in a picture safely, go for it, because it makes a picture all the more unique. Whether it is rain, snow, sleet, fire. Anything that you can have to add another element to your picture will up its value in the critic world, and that can boost your name. Just keep safety in mind and you should do just fine.

Chapter 6: Marketing and Making Money

If you are going at this solo, and not through a company, then you are going to have to market yourself. You do this by putting your pictures out there for the world to see. There are several ways to do this, you can post them on social media, which is free. You can send them out to various companies, which will cost print fees and postage. You can also find someone to promote your photos for you which would also cost a fee. A personal favorite here is social media. It is free and can reach thousands of people instantly. All you have to do is share it. Be sure to water mark it though, because putting it out there can tempt people to steal unmarked work and mark it themselves.

Instagram is a very popular platform where you can share and hashtag people who may take interest in your photos. Over time you will organically grow a following allowing you more opportunities to monetize your photos and talents.

You will make most of your money through selling your pictures. Attending various sporting events will also allow you

the opportunity to network with event planners. Create relationships with these people so that eventually they may pay you to be their official photographer at upcoming sporting events. It is not an instantaneous process, but it can bring you in a lot of money in the long run. Make sure that you are getting paid enough to cover your cost of travel, food, and lodging, etc. Otherwise you are not really making money at all.

Conclusion

Thank you again for purchasing this book. I hope that you enjoyed the contents you read, and found that you were given information in an entertaining manner.

If you like the book, please leave a review on Amazon. Thank you!

www.ingramcontent.com/pod-product-compliance
Lightning Source LLC
Chambersburg PA
CBHW061223180526
45170CB00003B/1133